LITTLE BIT

Comes to America

LITTLE BIT
Comes to America

STAR SHERMAN

XULON PRESS

Xulon Press
2301 Lucien Way #415
Maitland, FL 32751
407.339.4217
www.xulonpress.com

Printed in the United States of America.

ISBN-13: 9781545628294

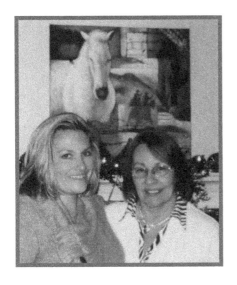

Stacia and her mother, Star

FOR CHRISTINE, STACIA AND MIKE,
LOVING CARETAKERS OF LITTLE BIT.

Stacia and her husband, Mike

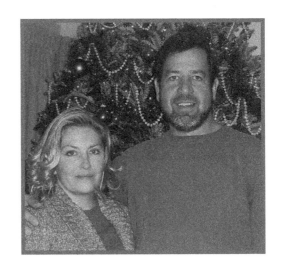

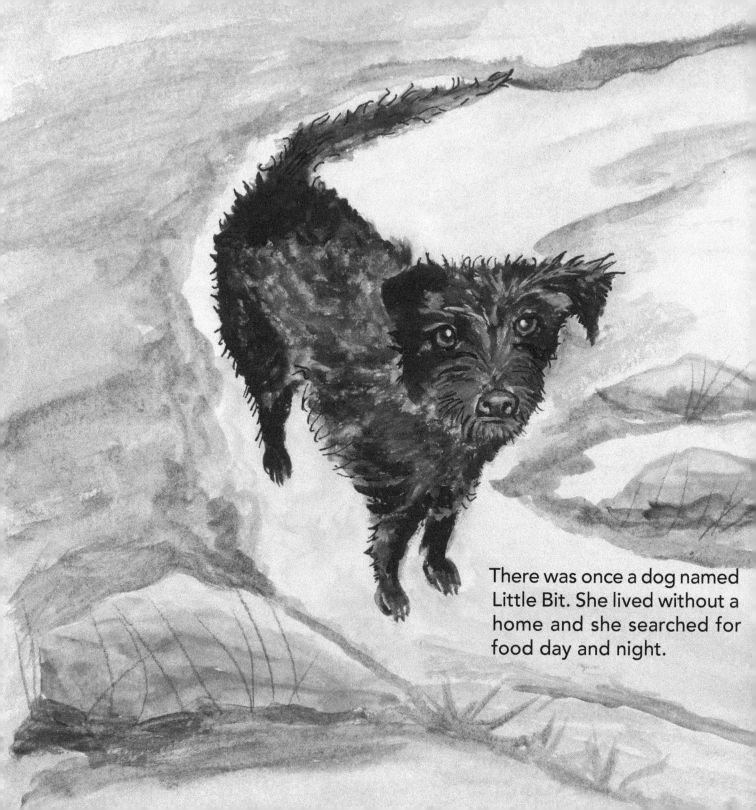

There was once a dog named Little Bit. She lived without a home and she searched for food day and night.

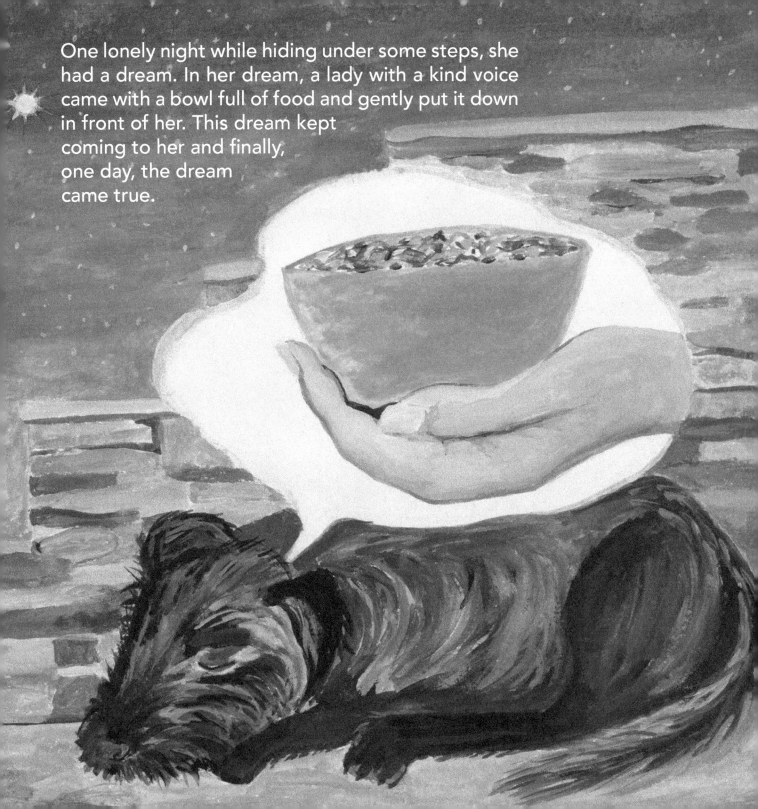

One lonely night while hiding under some steps, she had a dream. In her dream, a lady with a kind voice came with a bowl full of food and gently put it down in front of her. This dream kept coming to her and finally, one day, the dream came true.

One day while looking for food, a kind lady picked her up and took her into her home.

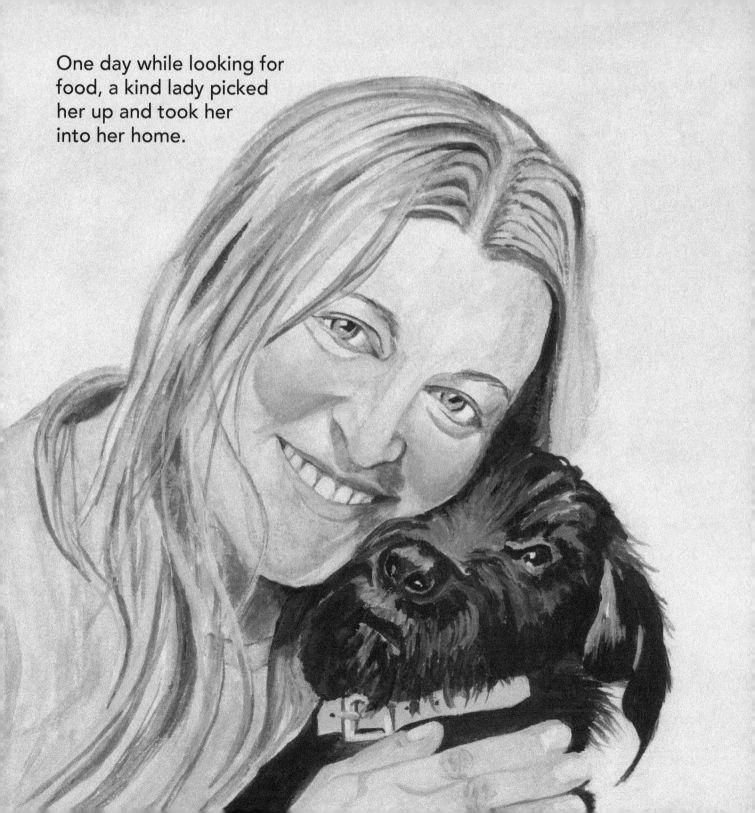

The lady had a bowl full of food for Little Bit. At last her aching, empty stomach was stronger than her fear and she went to the bowl and began to eat.

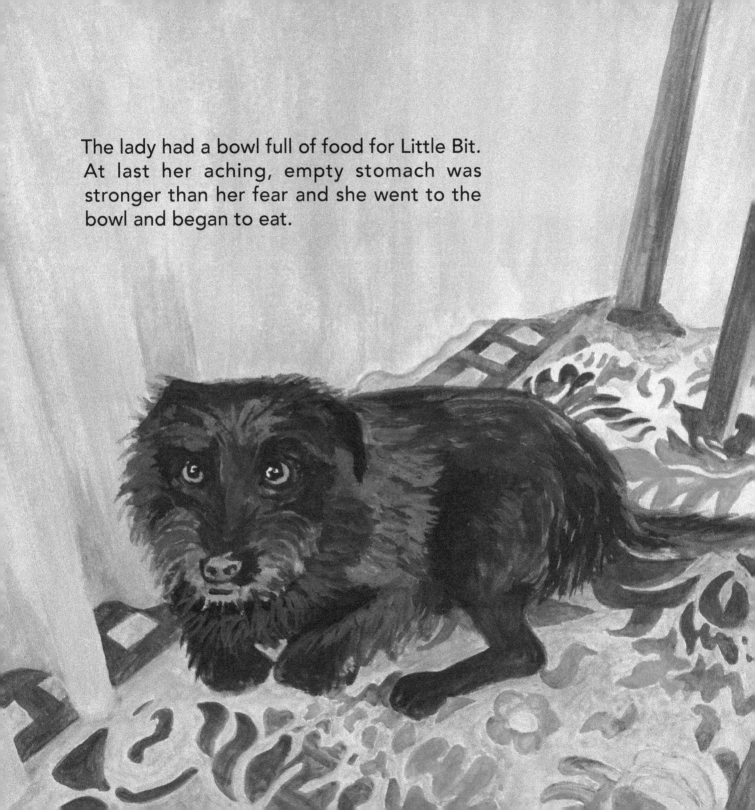

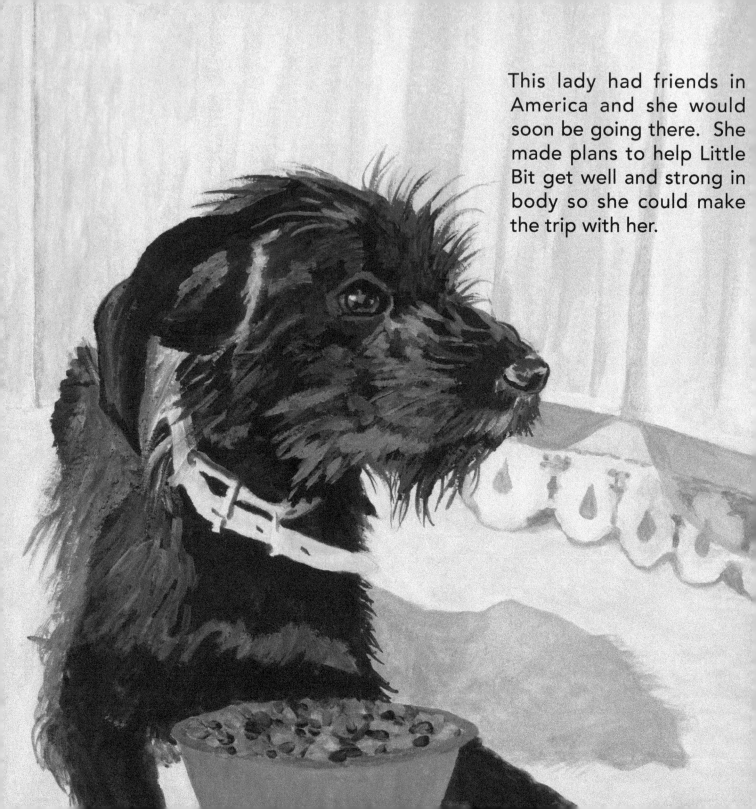

This lady had friends in America and she would soon be going there. She made plans to help Little Bit get well and strong in body so she could make the trip with her.

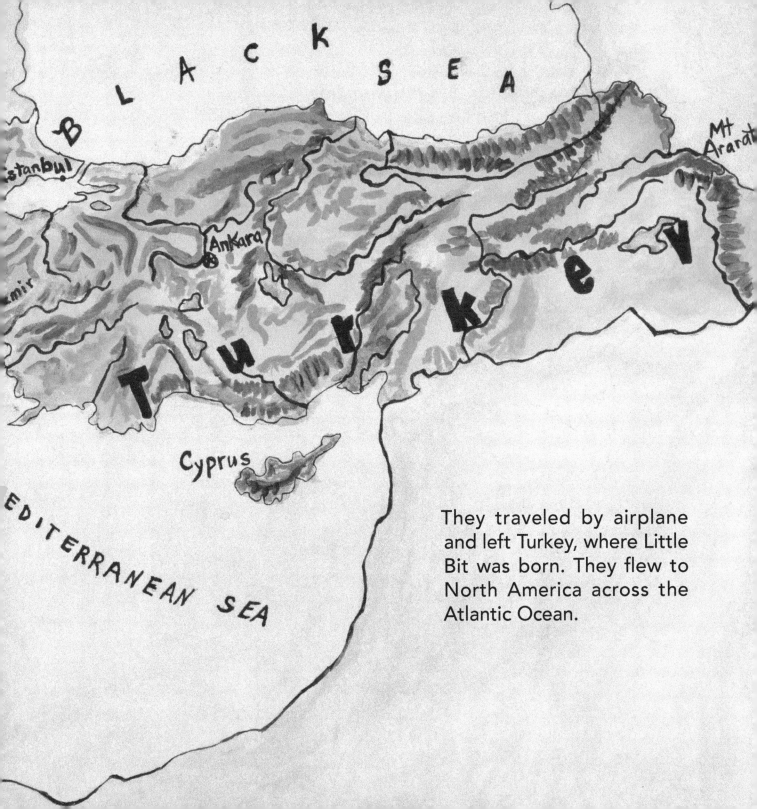

They traveled by airplane and left Turkey, where Little Bit was born. They flew to North America across the Atlantic Ocean.

Little Bit was afraid of the noise from the airplane engines and the feeling she got when they went high into the sky, but soon the flight was over and they landed in Boston.

When they were off the plane, they had to go through customs. Little Bit was now an immigrant.

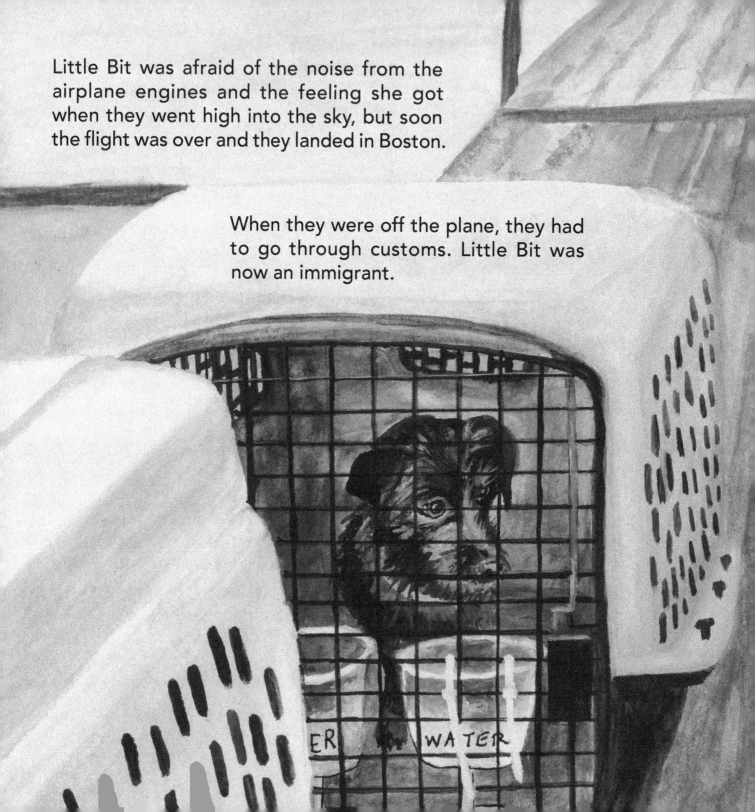

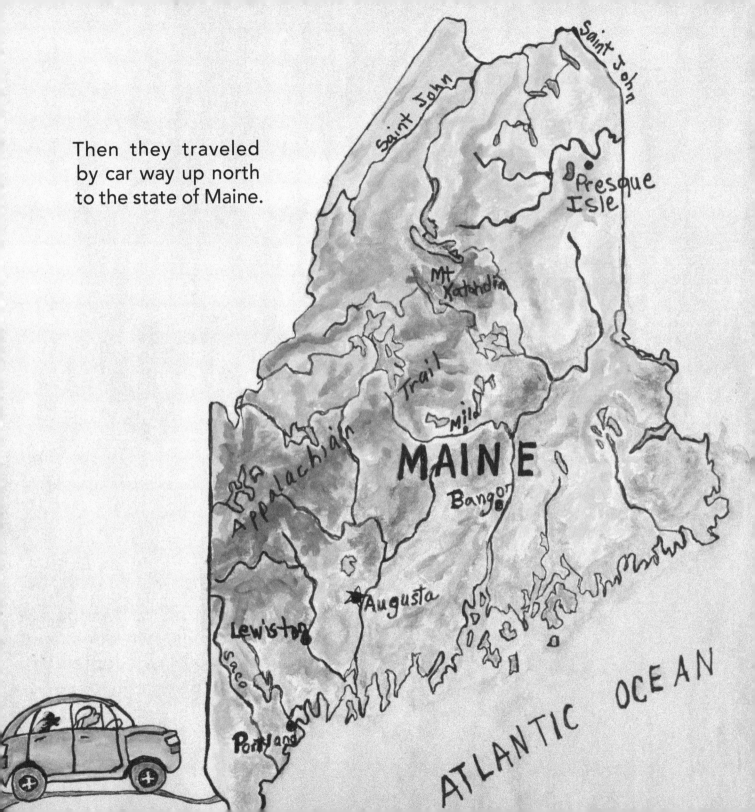

Then they traveled by car way up north to the state of Maine.

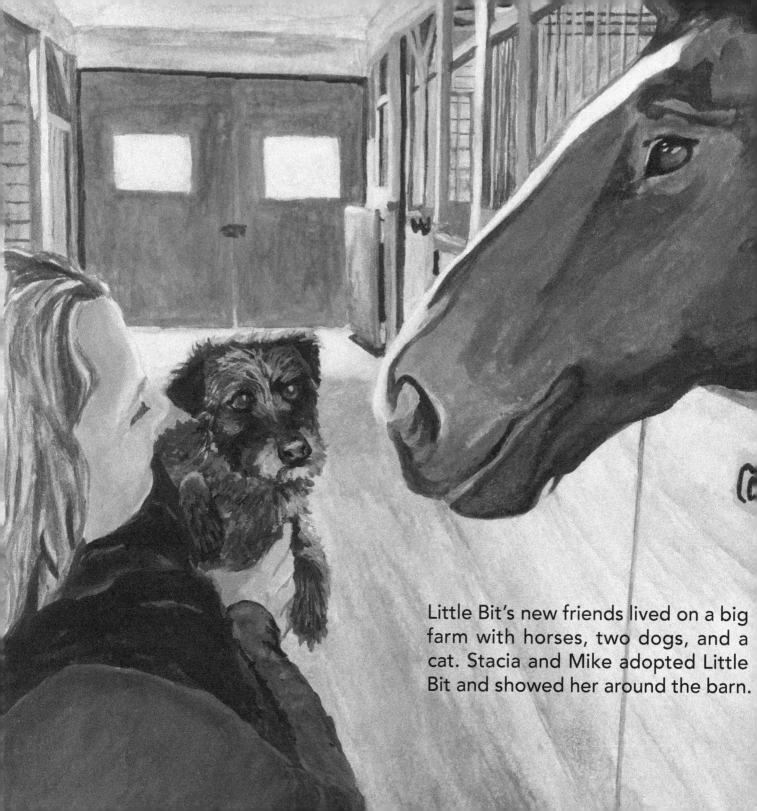

Little Bit's new friends lived on a big farm with horses, two dogs, and a cat. Stacia and Mike adopted Little Bit and showed her around the barn.

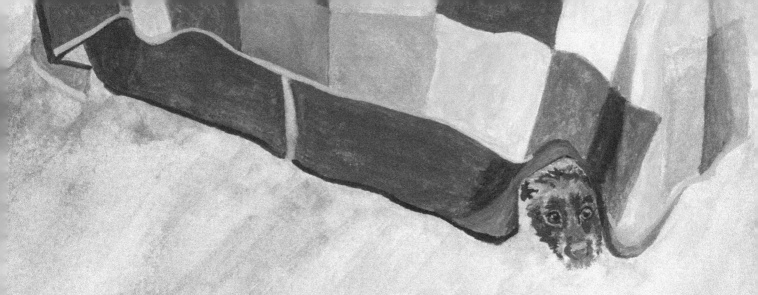

Eventually, Little Bit's favorite spot was in front of the fireplace; however, when she first arrived she was still frightened and would hide under the bed.

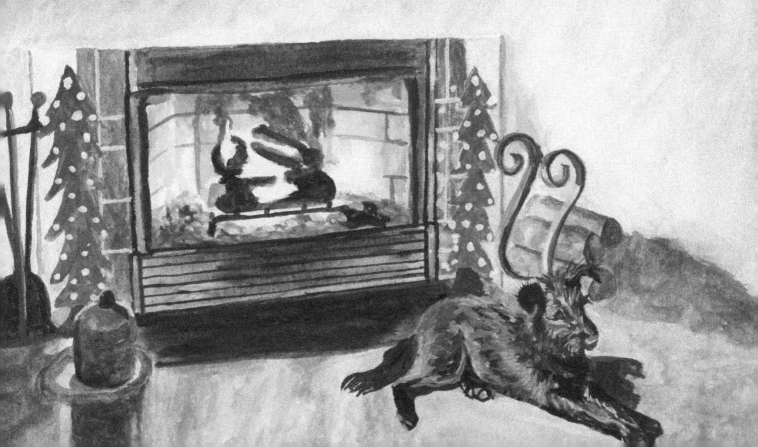

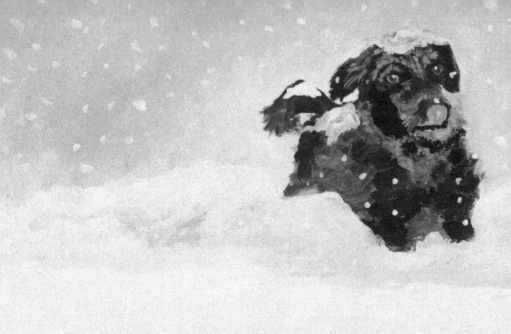

Now, you can find Little Bit on the farm chasing butterflies in summer and catching snowflakes on her tongue in winter. She is no longer afraid, has plenty to eat and is very happy in her forever home.

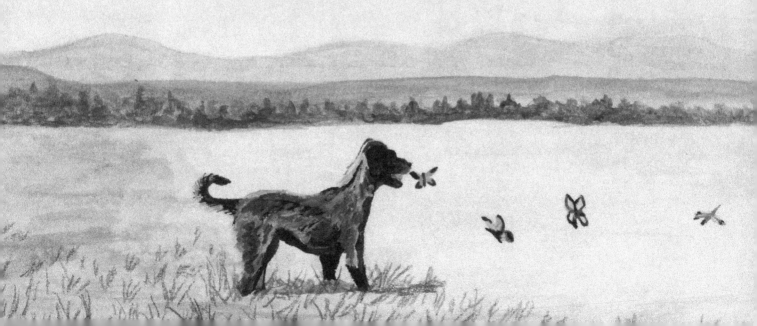

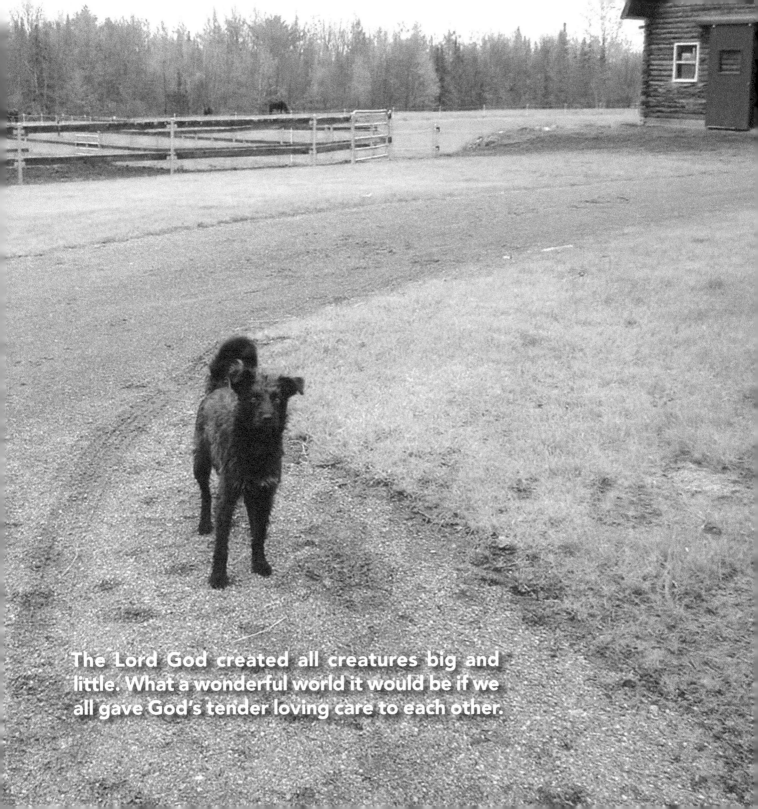

The Lord God created all creatures big and little. What a wonderful world it would be if we all gave God's tender loving care to each other.

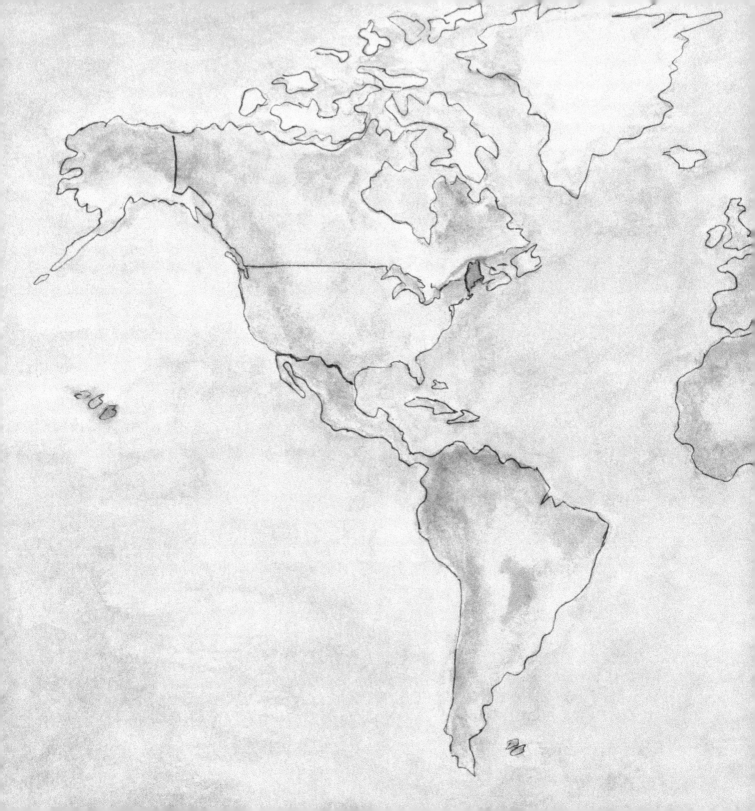

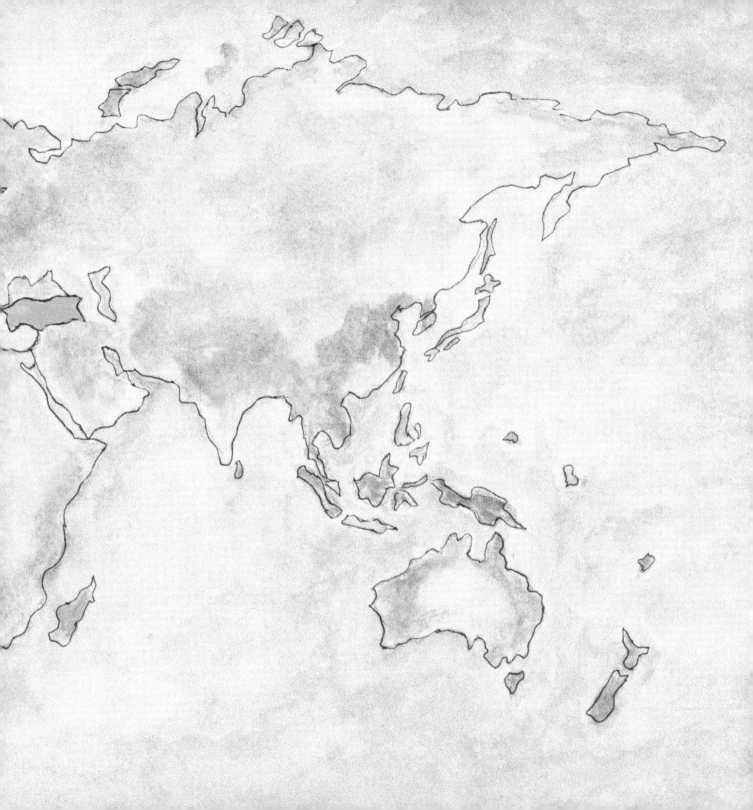

CPSIA information can be obtained
at www.ICGtesting.com
Printed in the USA
LVHW06*0220260318
571145LV00006B/121/P